CHRISTOPHER HART'S DRAW MANGA NOW!

Shoujo Style

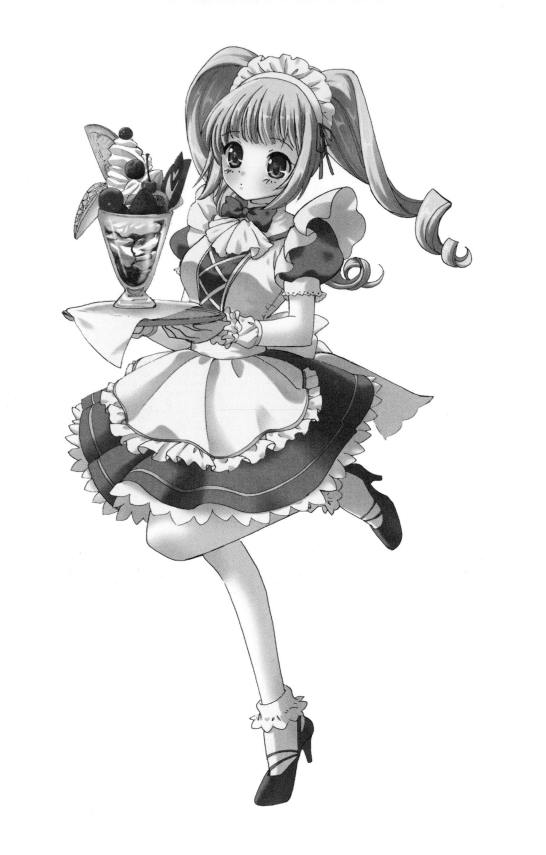

CHRISTOPHER HART'S DRAW MANGA NOW!

Shoujo Style

Christopher Hart

Watson-Guptill Publications
New York

Compilation copyright © 2013 by Christopher Hart, Cartoon Craft LLC, Star Fire LLC, and Art Studio LLC

Published in the United States by Watson-Guptill Publications, an imprint of the Crown Publishing Group, a division of Random House LLC, a Penguin Random House Company, New York.

www.crownpublishing.com
www.watsonguptill.com

WATSON-GUPTILL and the WG and Horse designs are registered trademarks of Random House LLC.

This work is based on the following titles by Christopher Hart published by Watson-Guptill Publications, an imprint of the Crown Publishing Group, a division of Random House LLC.: *Manga Mania Shoujo*, copyright ©2004 by Star Fire LLC; *Manga Mania Bishoujo*, copyright © 2005 by Star Fire LLC; *Manga for the Beginner Shoujo*, copyright ©2010 by Cartoon Craft LLC; and *Manga for the Beginner Kawaii*, copyright ©2012 by Cartoon Craft LLC.

Library of Congress Cataloging-in-Publication Data

Hart, Christopher
 Christopher Hart's draw manga now!: shoujo style/Christopher Hart.—
First edition.
 p. cm
1. Comic books, strips, etc.—Japan—Technique. 2.
Cartooning—Technique. 3. Comic book characters. I. Title. II. Title: Shoujo style.
 NC1764.5.J3H36919 2013
 741.5'1—dc23 2013028890

ISBN 978-0-385-34585-9
eISBN 978-0-385-34586-6

Cover and book design by Ken Crossland
Printed in the United States of America

10 9 8 7 6 5 4 3 2 1
First Edition

Contents

Introduction

Shoujo is perhaps the best-loved, most recognizable manga style in the world. If you're picking up this book, you probably have a basic understanding of how to draw the sweet, charming, and bright-eyed characters of this genre. However, in addition to these defining features, shoujo characters wear outfits and hairstyles that are full of beauty and grace. The style in which a shoujo character dresses can reflect their personality, or character type. Therefore, it's very important to know how to draw the right accessories, outfits, hairstyles, and embellishments to take your shoujo characters to the next level. Manga fashion is fun, and the possibilities are endless. As you'll see, it's all about the important details.

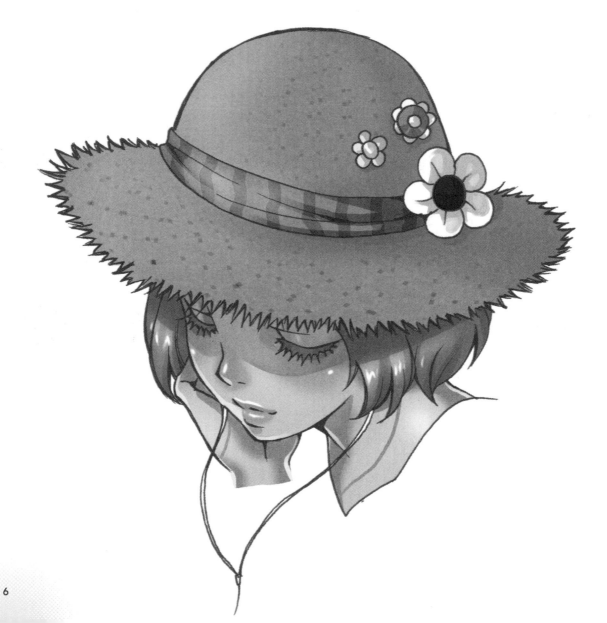

To the Reader

This book may look small, but it's jam-packed with artwork and instruction to help you dress, accessorize, and characterize the hugely popular characters of shoujo!

We'll start off by diving right in—past the basics—to the famous character types that make shoujo so well loved. There's everyone from rock stars to girls in traditional Japanese outfits, and loads of accessories to jazz them up. You might want to practice drawing some of the things in this section before moving on to the next one.

Then, it'll be time to pick up your pencil and start actually drawing complete shoujo characters! You can follow my step-by-step illustrations on a separate piece of paper, drawing the characters in this section using everything you've learned so far.

Finally, I'll put you to the test! The last section features images that are missing some key features. It'll be your job to finish these drawings, giving the characters the missing elements they need.

This book is all about learning, practicing, and, most important, having fun. Don't be afraid to make mistakes, because let's face it: every artist does at some point. Also, the examples are meant to be guides; feel free to elaborate and embellish as you wish. Before you know it, you'll be a manga artist in your own right!

Let's begin!

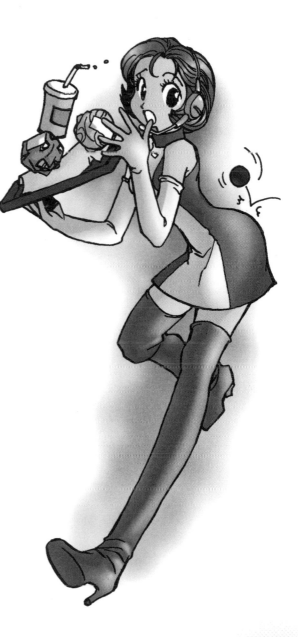

PART ONE
Let's Learn It

Hair

Hairstyles are very important to all manga characters, but especially to ones in the shoujo genre. Because they are teenagers, we can communicate their personalities by the way they wear their hair, whether it's wild, conservative, or carefree. And this is true for the boys in this book, too!

Popular Female Hairstyles

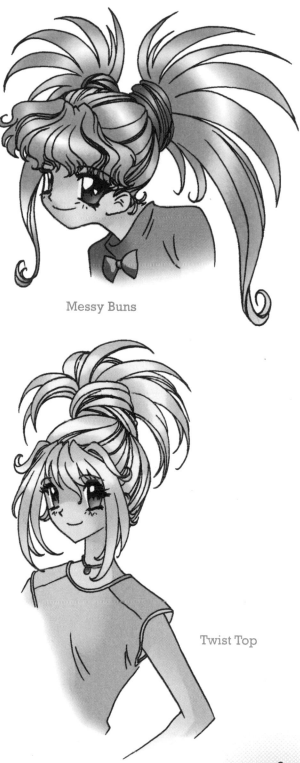

Messy Buns

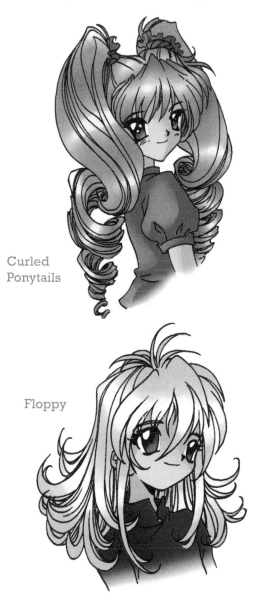

Curled Ponytails

Floppy

Twist Top

Popular Male Hairstyles

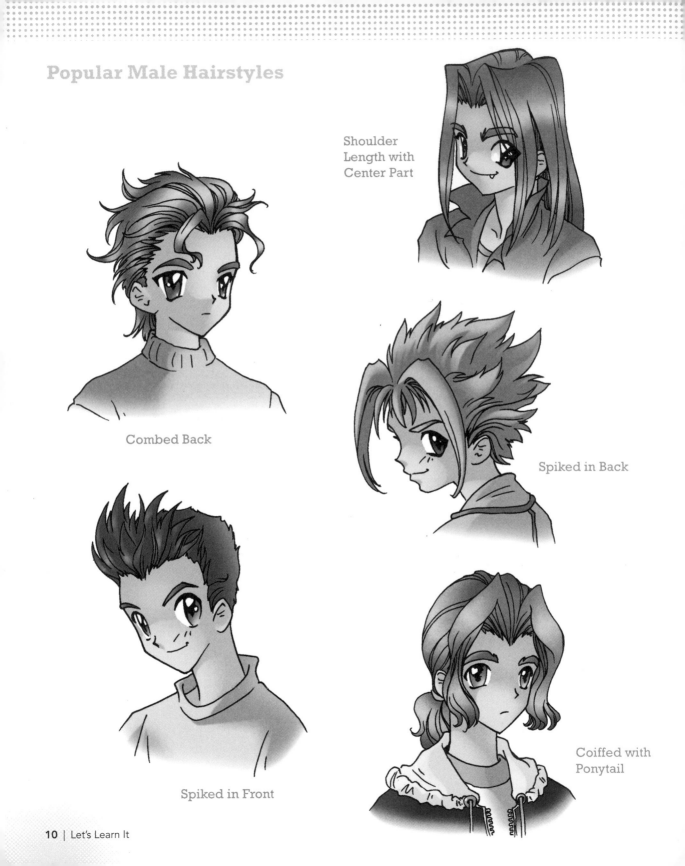

Shoulder Length with Center Part

Combed Back

Spiked in Back

Spiked in Front

Coiffed with Ponytail

Different Lengths

Short hair can be very sharp looking. It's a great match for characters with a hip, cosmopolitan look and style. You can also split the difference between short and long to create hairstyles of medium length; this is the most common style for the girl-next-door type, but you can use it on many other characters, too. Note that the longer the hair, the more swirls you must add to keep it graceful and visually interesting.

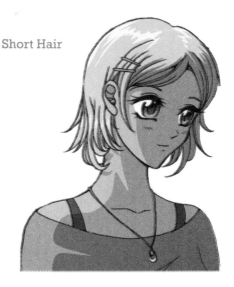

Short Hair

Pulled Back

Medium Hair

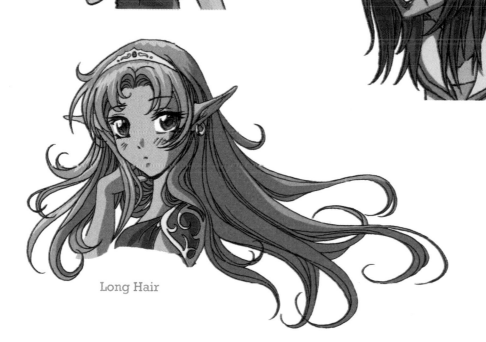

Long Hair

Stylized Hair

Beautiful hair is an intrinsic part of every character, and helps define a character's overall look. Length doesn't matter as much as the style and cut. The strands of hair are drawn with very thin lines, providing an elegant look. But not every strand needs to be drawn. Drawing a group of them will imply the rest. Don't be supercompulsive and attempt to draw ten thousand individual strands of hair on each character's head, or you'll drive yourself crazy. A character's hairstyle should always reflect and complement their outfit and general appearance. You'll see a bit more of this later, too.

Short Bob
This gives characters an especially cute look. Note that the hair curves inward as it frames her face; it doesn't hang straight down.

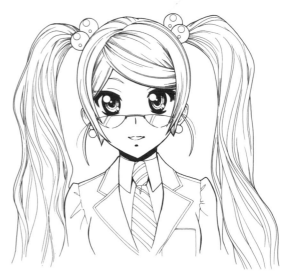

Superlong Pigtails
Length can add glamour to ordinary hairstyles.

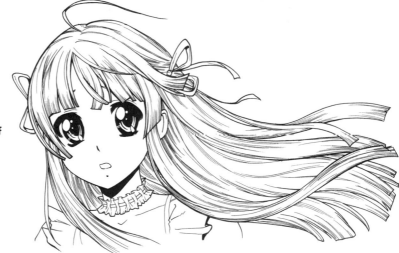

Windblown
Showing the effects of wind implies movement and, therefore, adds energy to the scene. It's also an effective way to underscore a feeling of emotional turbulence.

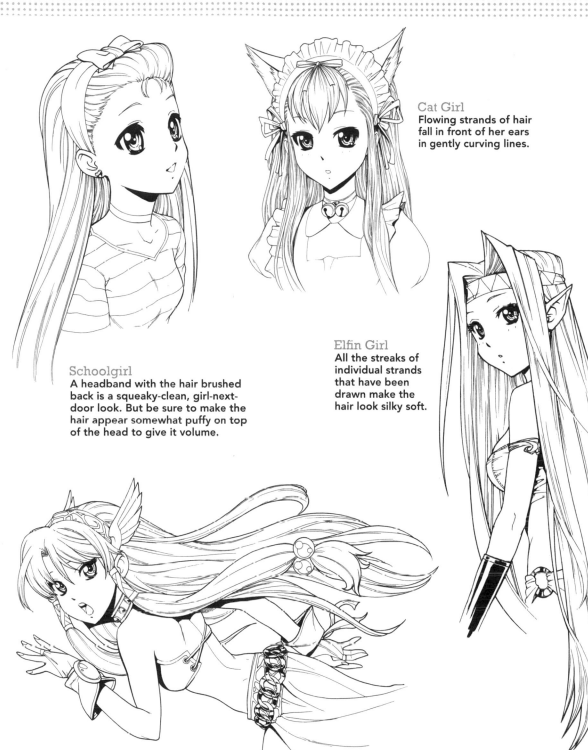

Cat Girl
Flowing strands of hair fall in front of her ears in gently curving lines.

Elfin Girl
All the streaks of individual strands that have been drawn make the hair look silky soft.

Schoolgirl
A headband with the hair brushed back is a squeaky-clean, girl-next-door look. But be sure to make the hair appear somewhat puffy on top of the head to give it volume.

Gothic-Style Magical Girl
Multiple groupings of long strands of hair sway up and down in the wind.

Expressions

Shoujo expressions are usually subtle, unless—and this is a big unless—they're expressing a strong emotion; then, you can go wild.

Of course, the eyes, eyebrows, and mouth are the primary drivers of expressions. But for shoujo girls, there's more: Use touches of makeup to enhance the features, and pay special attention to the shape of the eyelashes, elongating them on sultry or sad expressions. Also note how the hair moves, reflecting the state of emotions, flailing about in a stormy manner when the character is angry.

Upset
Keep your female characters pretty, even when they're outraged. Concentrate on the redness on her cheeks and ears.

Pleased
Closed eyes show extreme pleasure. The expression, therefore, relies more on the eyes than on the mouth. Note how thick her eyelashes are.

Frightened
As the eyes and mouth open wide, the face stretches to accommodate them. Notice that the hair flies about, reflecting the mood of the moment.

Sad
Looks of unhappiness are usually paired with downward-cast eyes. Hopeful looks often have the eyes and head looking upward.

Hands Help
Don't forget to use your characters' hands to add to their overall attitude, personality, and look. Notice how the hand gestures in these two examples help communicate the emotion of the character's expression, and help to establish their personality.

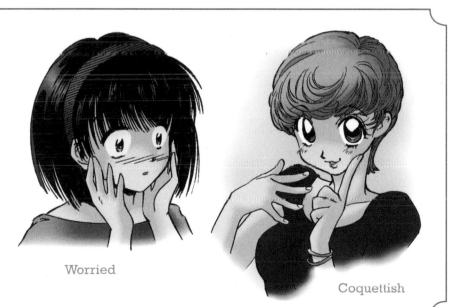

Worried

Coquettish

Gestures

The body reflects a character's state of mind. Use poses and gestures to add even more to a character's attitude. It shows the character's reaction to a thought or event. If two characters are sitting together, the one who is worried and deep in thought will sit in a different position from the other.

Each drawing here shows how pose, clothes, hair, and facial expression all combine to convey a certain emotion. Pay attention to the way the characters' clothing moves, folds, and drapes over their bodies with each pose. These drawings also give you a feel for how clothing can reflect a character's identity; a cheerful schoolgirl wears a frilly, ultra-peppy uniform, while a clumsy waitress wears an outrageous dress and tall heels (who can walk in those, anyways?).

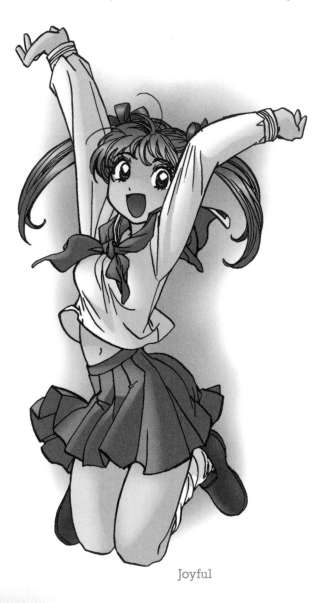

Joyful

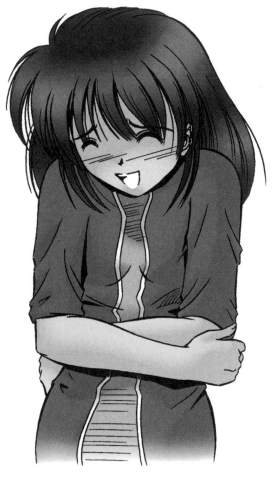

Giggling

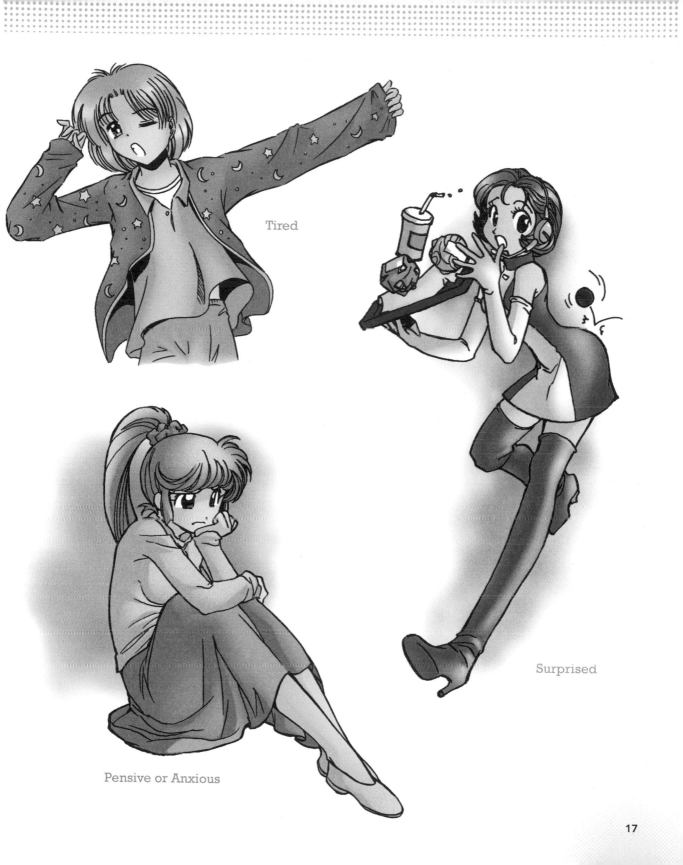

Tired

Pensive or Anxious

Surprised

Accessories & Embellishments

Hats, jewelry, flowers, gloves, the list goes on. These are just a few ways you can embellish a basic manga outfit. Try to pair up accessories that, together, reflect the overall mood or personality of a character. Bows, polka dots, and ruffles work well on a sweet, innocent character, while ornate details might be suitable for a more mature character.

Hats

To add a jazzy look to your characters, you can't beat stylish, colorful hats. Chic shoujo characters wear popular styles. Let these examples inspire you to create different embellishments for your characters. Be as bold and colorful as you can, and don't worry that being flashy will detract from the character—it only adds to the vitality of the character's overall design. And don't forget to make use of patterns, bows, ribbons, flowers, pompoms, brooches, and even earrings, braids, or gloves—the possibilities are endless!

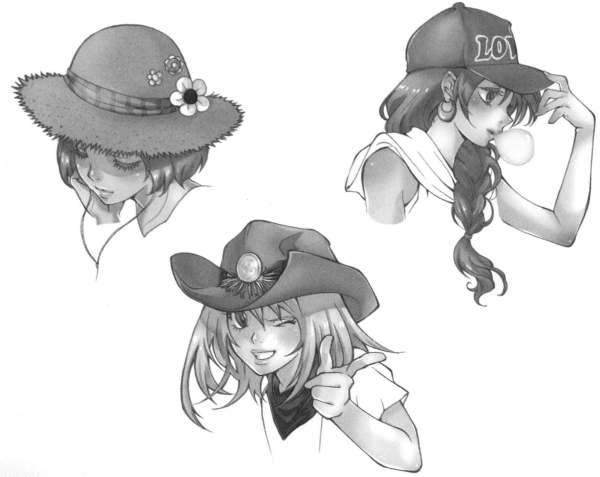

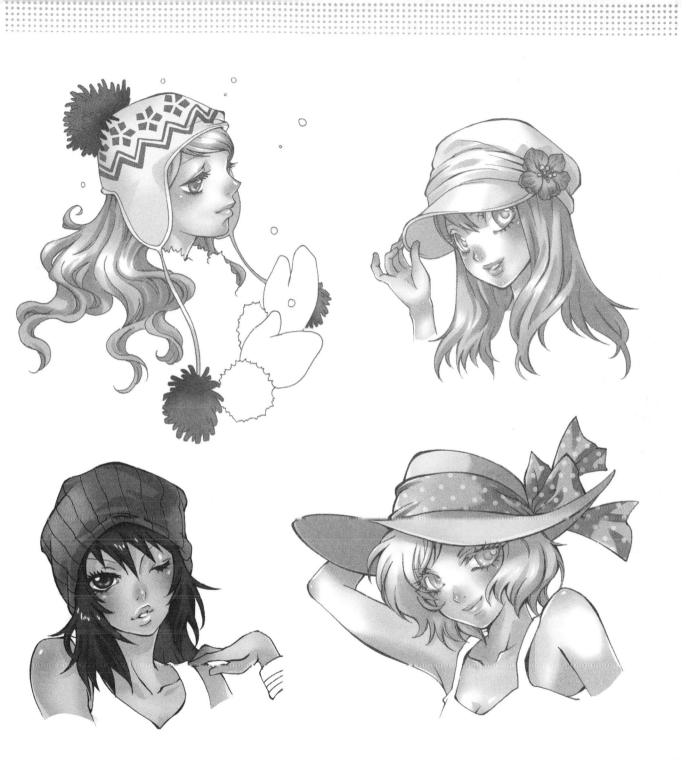

Gloves & Jewelry

You can liven up your hands by adding gloves and even mysterious tattoos.

Jewels should be based on actual, recognizable shapes, such as ovals, circles, squares, and rectangles. By repeating several examples of the same style of jewels on a single character, you can create a set of jewelry.

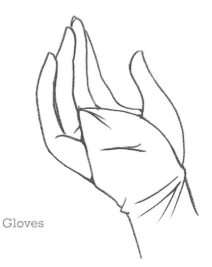

Gloves

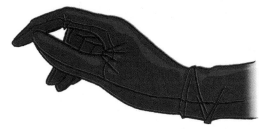

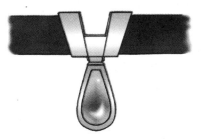

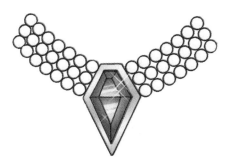

Necklaces

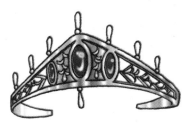

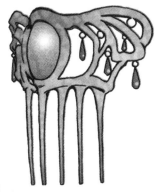

Hair Accessories

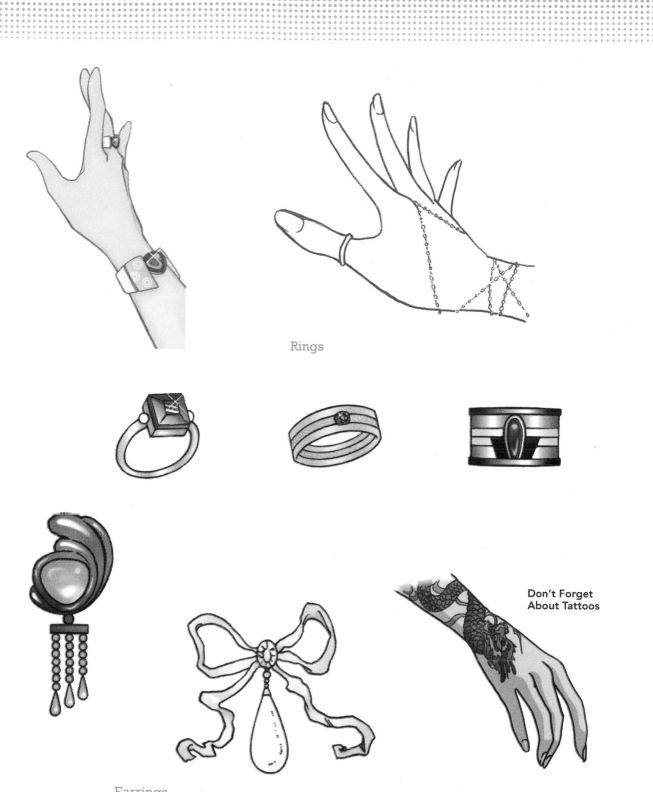

Rings

Earrings

Don't Forget
About Tattoos

More Feminine Details

In addition, shoujo artwork is embellished with delicate motifs—graceful decorations that create an overwhelming sense of beauty. These accessories and enhancements bring a character's look to the next level. You can put these on anything—skirts, tops, hats, even shoes!

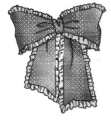
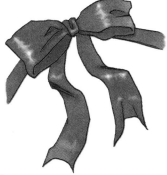

Bows

Don't let bows look so limp that they lose their form. Although a bow should be flexible and flap in the wind, it should also be a pleasing form.

Gathered Lace Trim

Draw the rippled edge of gathered lace trim before drawing the folds within it. This edge is a randomly drawn line that flows in and out. Once you've drawn the edge, indicate the fold lines, which create the gathered look of the lace trim.

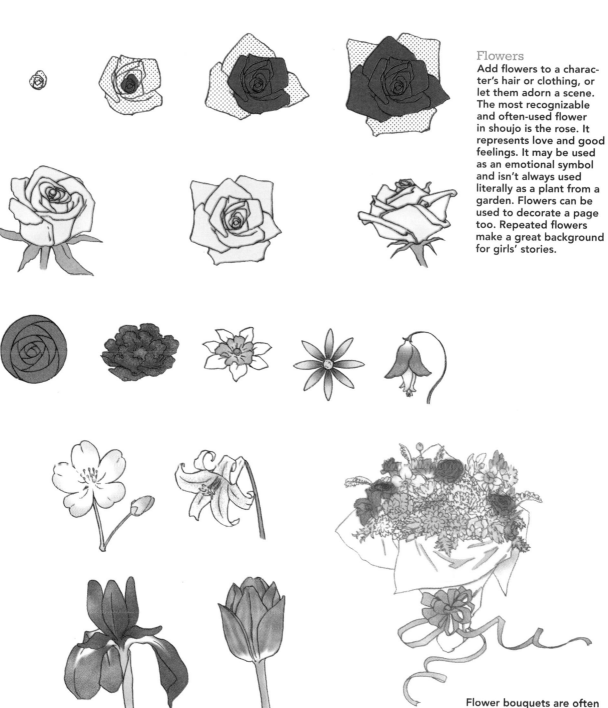

Flowers

Add flowers to a character's hair or clothing, or let them adorn a scene. The most recognizable and often-used flower in shoujo is the rose. It represents love and good feelings. It may be used as an emotional symbol and isn't always used literally as a plant from a garden. Flowers can be used to decorate a page too. Repeated flowers make a great background for girls' stories.

Flower bouquets are often given as gifts or held in hope by a character.

Mascots

Mascots are a must in shoujo, and are as much a part of manga style as jewelry, accessories, and glamorous outfits are. Everybody loves them because they're so cute. They usually attach themselves to one character in particular, as a pet might do. Unlike pets, however, they can pop in and out of existence at will. They're favorites, and readers always look forward to them. They can be silly, loving, loyal, and good-naturedly mischievous. They act as the confidante of one or more of the human characters in a story.

Cute mascots are often based on real animals but made to look squeezable and adorable. They generally display the same proportions as baby animals, having long ears, a short nose, a small mouth, and a large head in contrast to the body, and are round and plump (or fluffy).

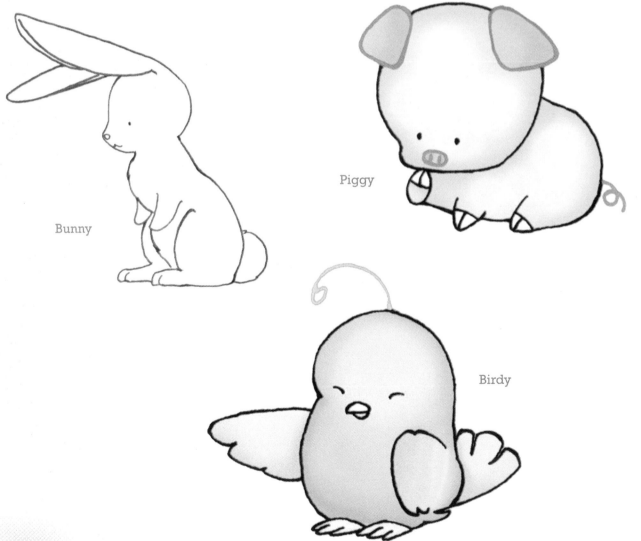

Bunny

Piggy

Birdy

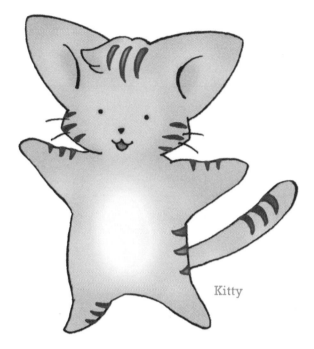

Kitty

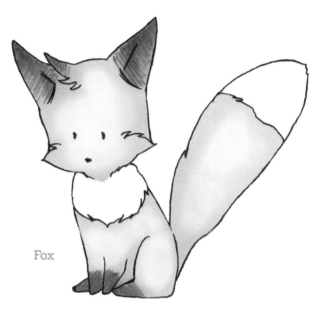

Fox

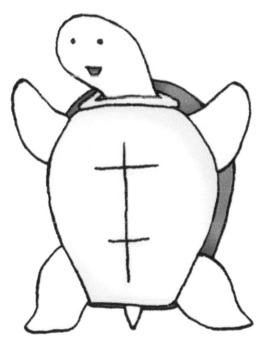

Turtle

Unicorn

Shoes

What look is complete without shoes? Whether you give your character some spiky heels, ethereal sandals, trendy boots, or schoolgirl sneakers, shoes are essential for tying together a character's outfit. Make sure that the shoes and outfit complement each other. For example, you would never see a young, bright-eyed shoujo girl wearing stiletto heels, and casual sneakers might look strange on an ultra-glamorous bishoujo character!

The foot will always appear more attractive when the heel is lifted off the ground. This holds true whether your character is wearing stiletto shoes or space-fighter-pilot boots. The elevated heel causes the bridge of the foot to slope downward, elongating the look of the leg and creating a smoothly tapered appearance.

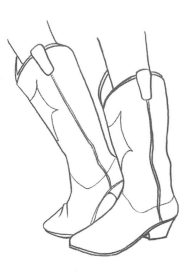

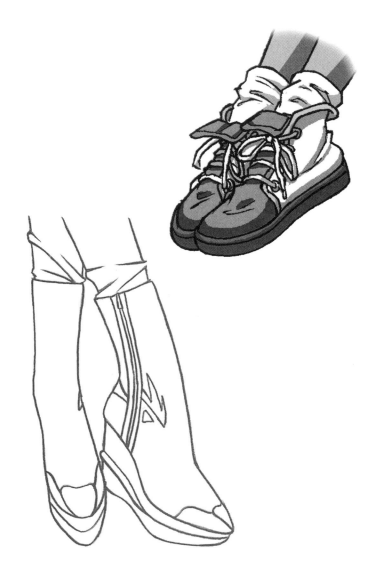

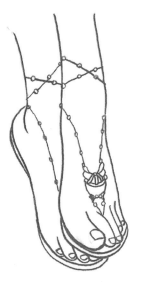

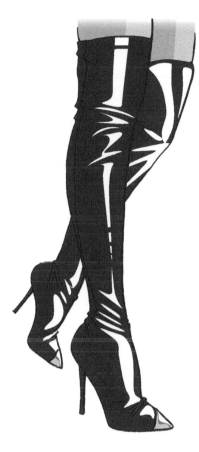

Feet in high heels make the legs look longer.

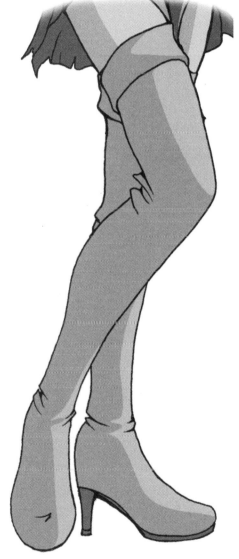

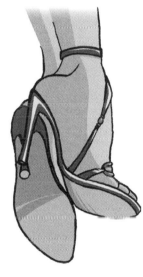

Soles of high-heeled shoes should be clearly visible in rear view.

Bridge of foot slopes downward.

Clothing Basics

Clothing is an important tool in communicating information about your characters to the reader. Plus the clothing on characters is pretty important in the shoujo and bishoujo genres. You want the clothing and costumes to look good, and to that end, a little basic knowledge about how fabric interacts with the body is helpful.

Clothing is basically drapery that has been hung on a person instead of on a window. The body under the fabric causes many folds, creases, and wrinkles to appear.

Clothes are meant to hang off the body. As they hang, gravity pulls them down, causing folds. There are certain stress points on the body that bear more of the fabric's weight; this is where most of the folds will occur. When the body moves, those stress points can change, and therefore, the folds will have to be adjusted. Take a look at some of the dynamics involved.

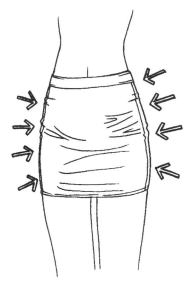

Mini Skirt
The mini skirt hugs the hips, creating horizontal folds.

Long Skirt
As with the pleated skirt, the waistband of the long pencil skirt supports the weight of the skirt, creating a few small creases at the top. Since there are no pleats, longer vertical folds appear down the length of the dress.

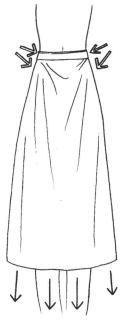

Pleated Skirt
The waistband of the pleated skirt holds up its weight, resulting in some small horizontal folds. The pleats hang straight down with a few short vertical folds.

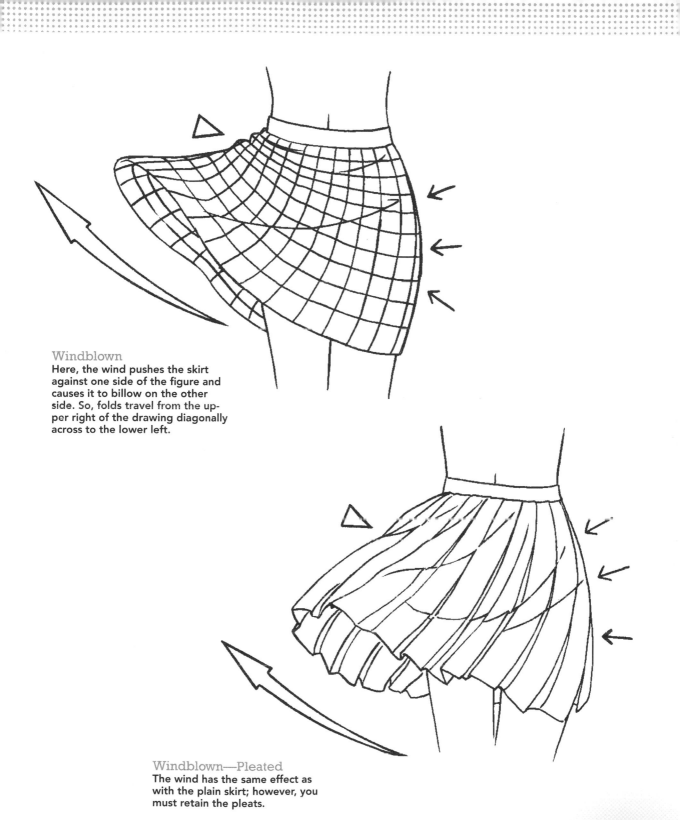

Windblown

Here, the wind pushes the skirt against one side of the figure and causes it to billow on the other side. So, folds travel from the upper right of the drawing diagonally across to the lower left.

Windblown—Pleated

The wind has the same effect as with the plain skirt; however, you must retain the pleats.

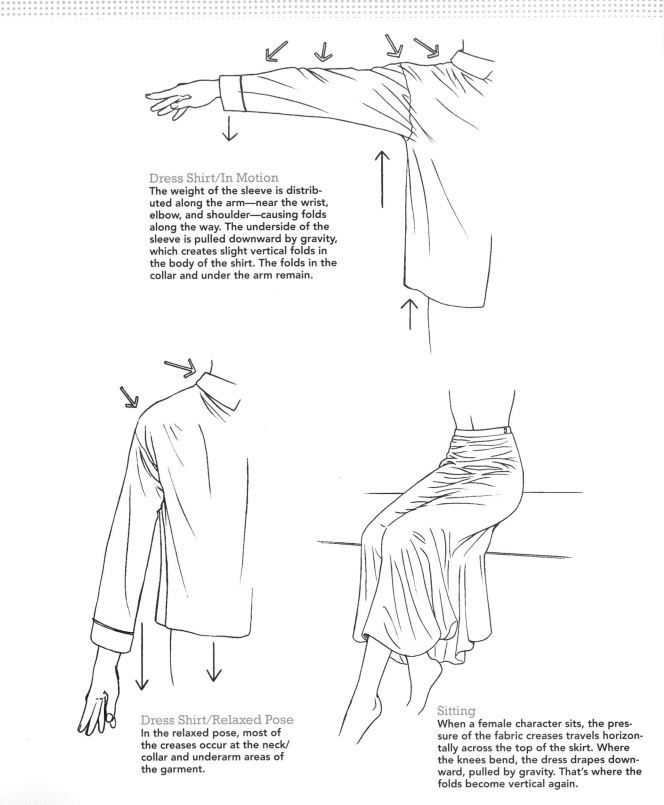

Dress Shirt/In Motion

The weight of the sleeve is distributed along the arm—near the wrist, elbow, and shoulder—causing folds along the way. The underside of the sleeve is pulled downward by gravity, which creates slight vertical folds in the body of the shirt. The folds in the collar and under the arm remain.

Dress Shirt/Relaxed Pose

In the relaxed pose, most of the creases occur at the neck/collar and underarm areas of the garment.

Sitting

When a female character sits, the pressure of the fabric creases travels horizontally across the top of the skirt. Where the knees bend, the dress drapes downward, pulled by gravity. That's where the folds become vertical again.

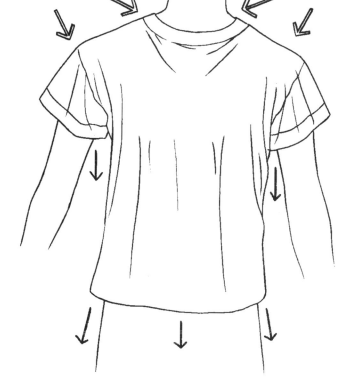

T-shirt/Relaxed Pose
The collar and underarms bear most of the weight and compression of the fabric, so that's where most of the folds are located.

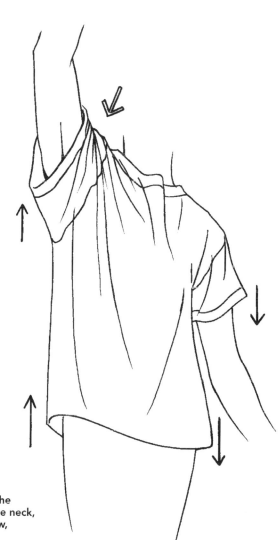

T-shirt/In Motion
Lifting the arm compresses the shirt fabric at the crook of the neck, resulting in a bunch of narrow, somewhat diagonal folds.

Outfit Inspiration

Schoolgirls are some of the most popular manga characters and are seen in tons of popular Japanese comics; these examples are based on authentic Japanese school uniforms. The two types are the private school uniform and the public school (sailor) uniform. Service professions—such as nurses, waitresses, and maids—are popular in bishoujo manga. Don't shoot the messenger! These characters just happen to be very popular in manga. These outfits can be sleek and clean, or ornate, with lots of ruffles, but they should always look very cute and feminine. Traditional Japanese costumes are worn for special occasions and ceremonies. The kimono has long sleeves and shows off the character's sleek figure. An obi (sash) is tied around the waist.

Then there are clothes that are more casual, and Western-looking; your shoujo characters might wear these outfits to school, to play sports, to hang out at the mall, or even on a date! The possibilities are endless, so have fun with these. Try as many variations as you can possibly think of.

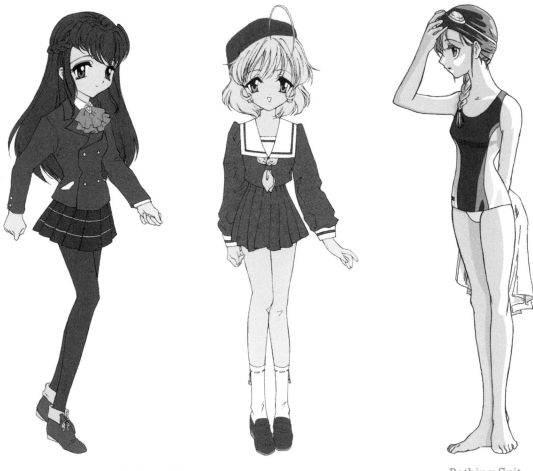

Schoolgirls

Bathing Suit

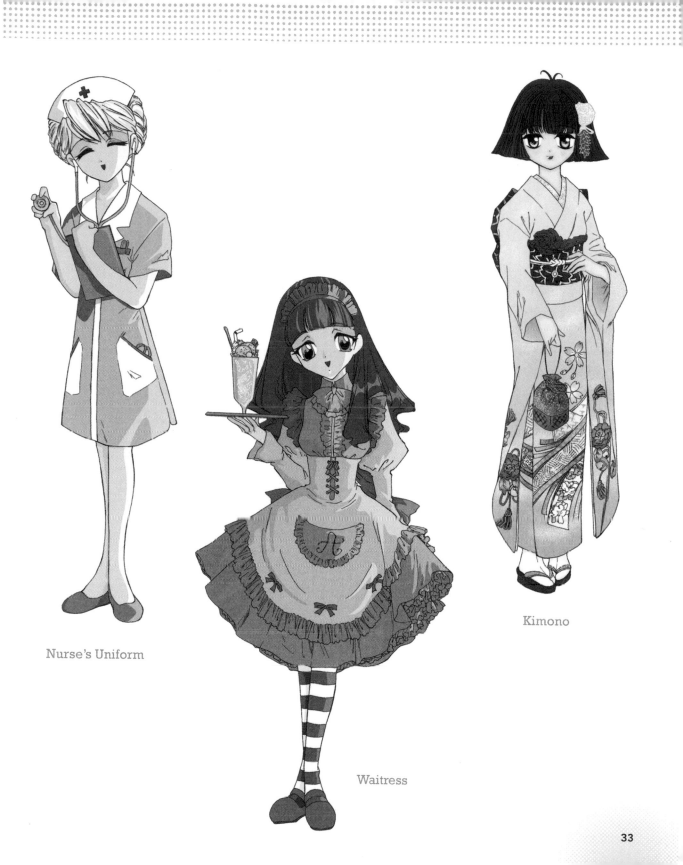

Nurse's Uniform

Waitress

Kimono

Even More Outfits

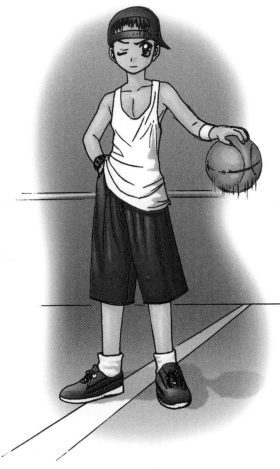

Basketball Uniform

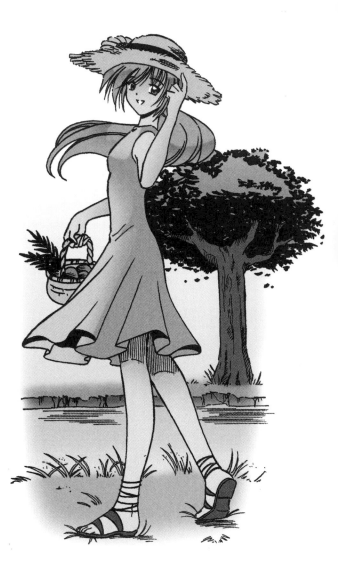

Breezy Sundress

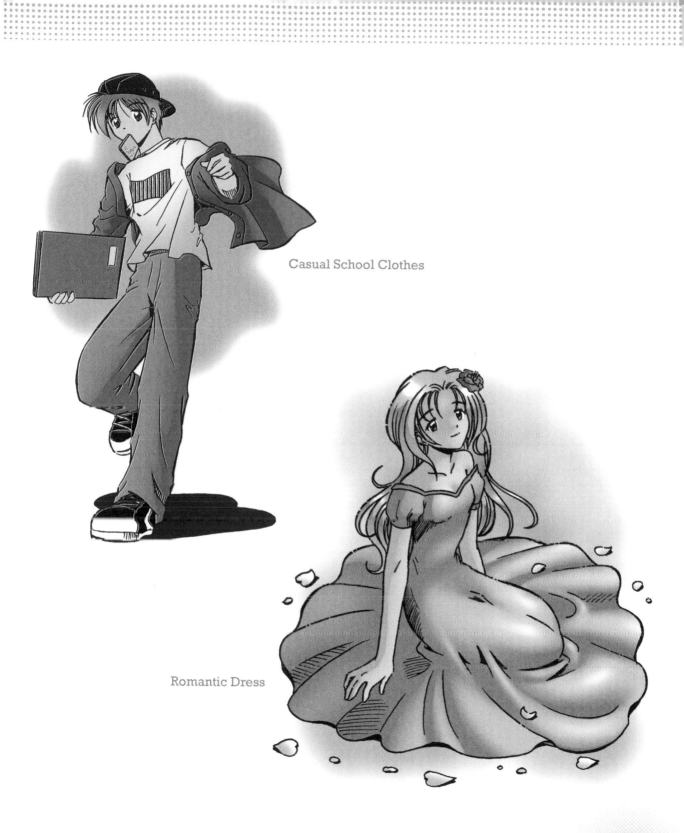

Casual School Clothes

Romantic Dress

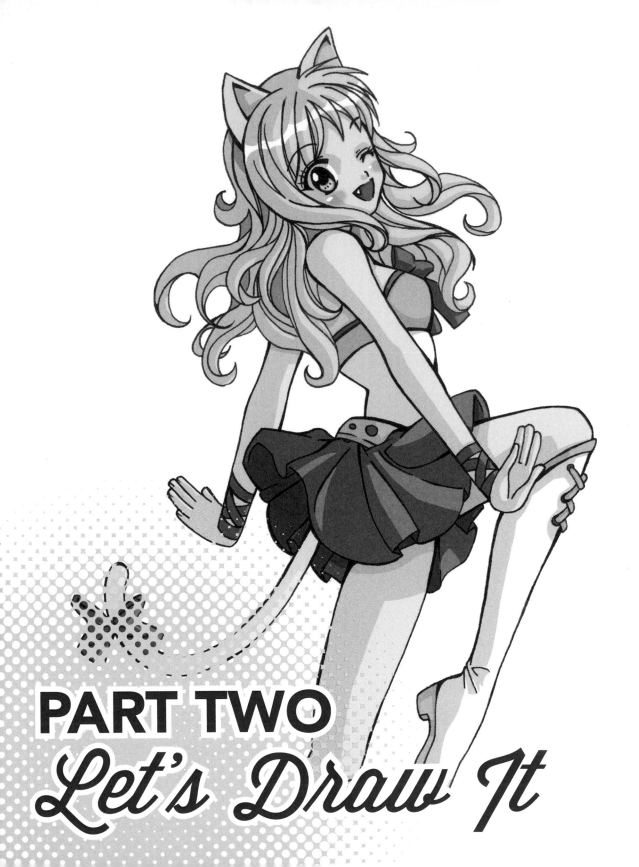

PART TWO
Let's Draw It

Slumber Party Girl

Here's a girl in a classic sitting pose. The curve in the small of her back pushes the torso forward, making the drawing appear more lifelike. She wears comfy slippers and pajamas. Have fun with your characters' hair; the more exaggerated and brightly colored, the better! This look is all about fun.

Spine curves one way . . .
. . . and then the other.

Runner

Here's a determined track star. Between competitions, this "strictly business" athlete can be seen training, hitting the pavement and logging in those miles. She wears shorts, a windbreaker, and a headband or sweatband. Does she need the kneepads and the extra-high socks? Not likely. But, hey, if it looks cool, draw it!

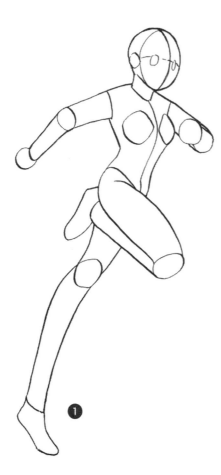

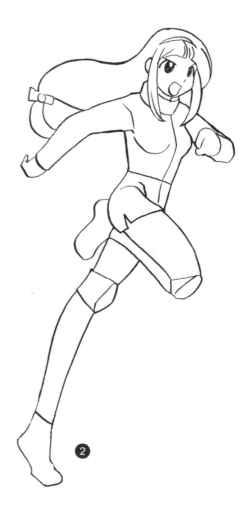

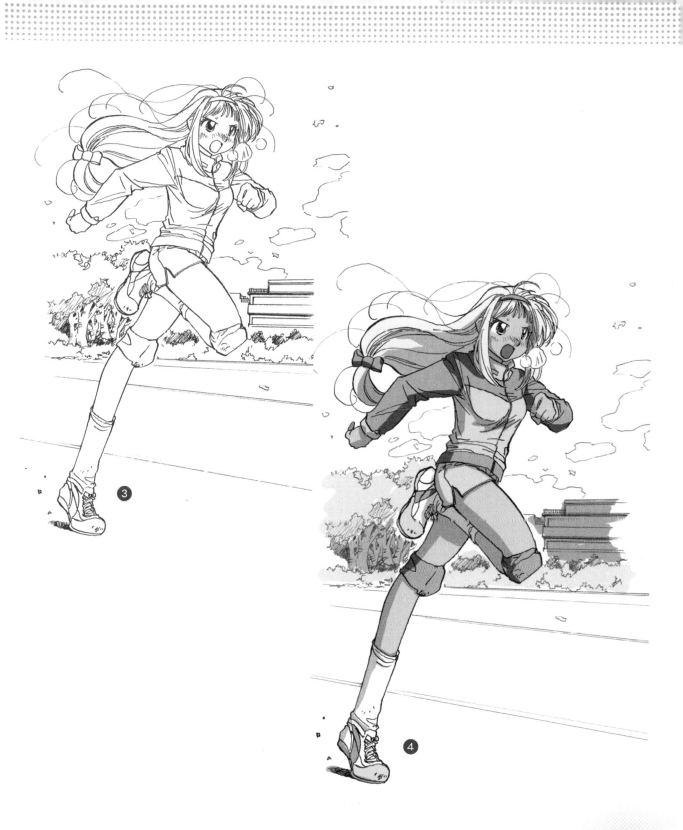

Gymnast

Sports are a *big* part of Japanese culture and tradition. Uniforms are not flashy and are almost always traditional in look. Athletic achievement combined with grace and beauty is what gymnastics are all about, and therefore, gymnasts make great characters for manga. The costume is easy. It's the swirls of handheld ribbon that provide the visual interest. Draw the ribbon in repeating spirals. The hair must be clipped back and neat. Long, flowing hair would interfere with the character's moves. Ponytails are the favored style.

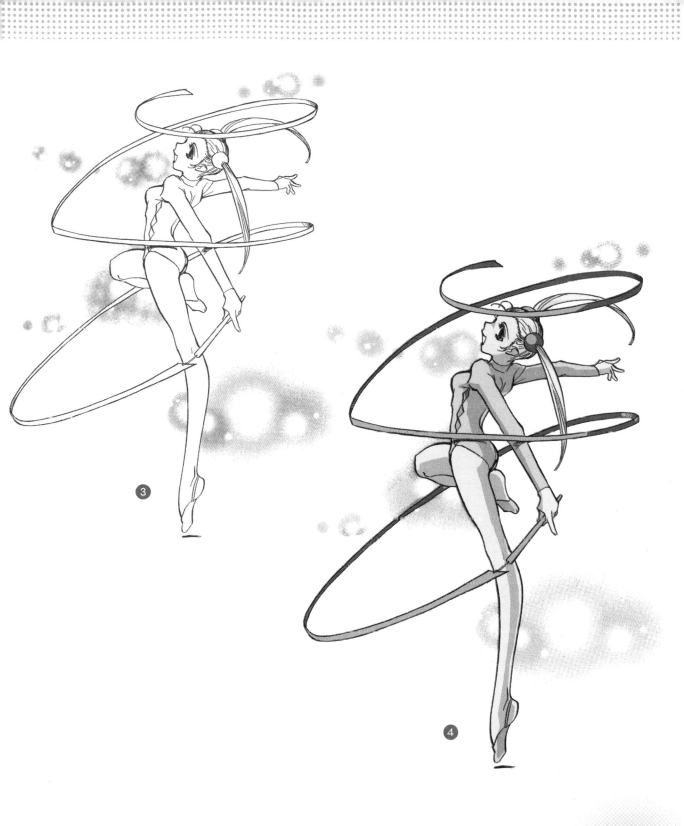

Pop Star

This is a J-Pop star, or Japanese pop star. J-pop is a huge trend in Tokyo. Pop star outfits range all the way from the somewhat mild, like this outfit, to the totally outrageous and loony.

When you draw this type of character, you want the clothes, hair, and body—everything—to be moving to the beat. Nothing in the picture should be static. Many rock singers use a headset, rather than a handheld microphone, in concert. But to quickly communicate her identity to the reader, the more obvious prop (the handheld mic) is the best choice.

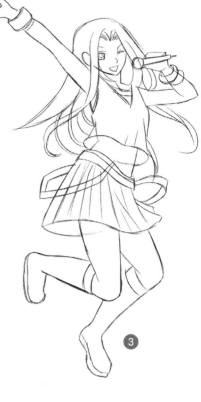

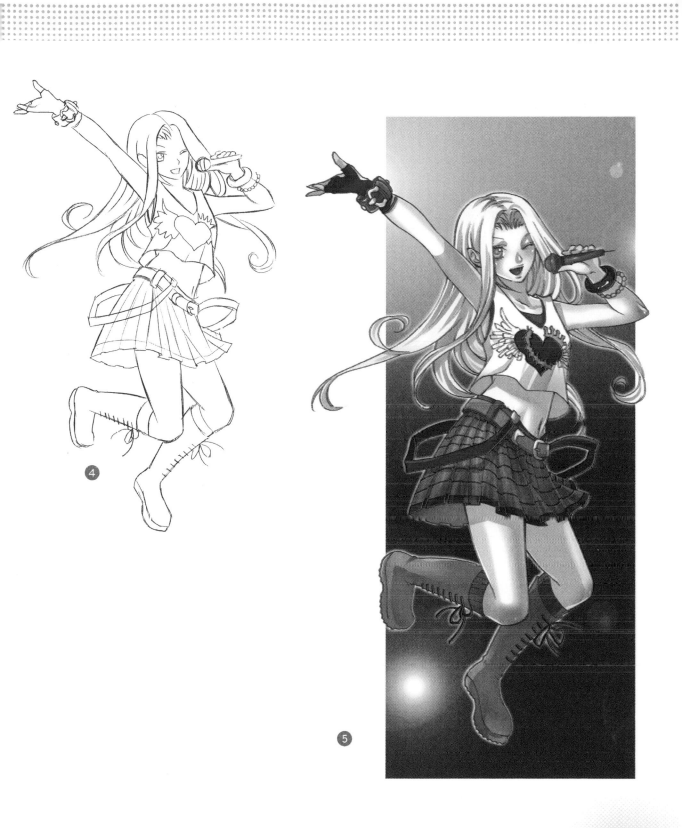

Science Girl

Just because a character is a mad scientist doesn't mean she can't be alluring and stylish. Some say villains make the best characters, because they're flamboyant and personality driven. Female villains are typically excitable and scheming. Shoujo villainesses are typically drawn with extra-long legs, with a curvaceous torso and long, elegant arms. Costuming is an essential part of character design.

Highly intelligent characters usually wear glasses. They're also known for wearing lab coats. The red dress and purple leggings add a touch of glamour to the look, and the hair is equally tempestuous. The clipboard is a must-have doctor prop. Forget stethoscopes and mirrored headbands, as those are old-fashioned cartoon stereotypes.

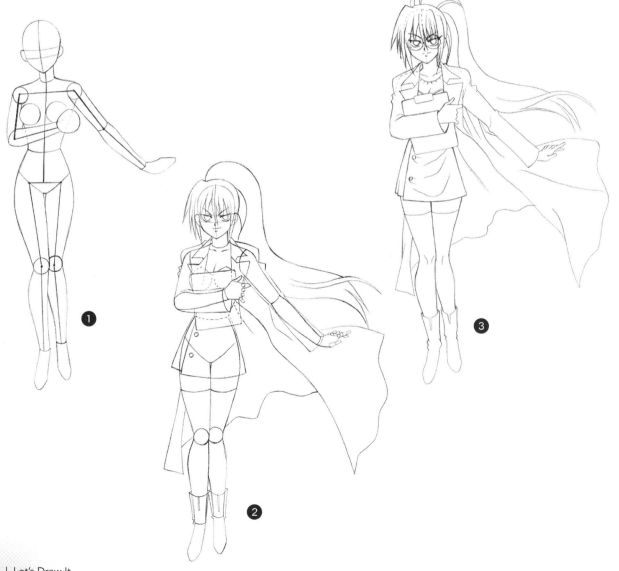

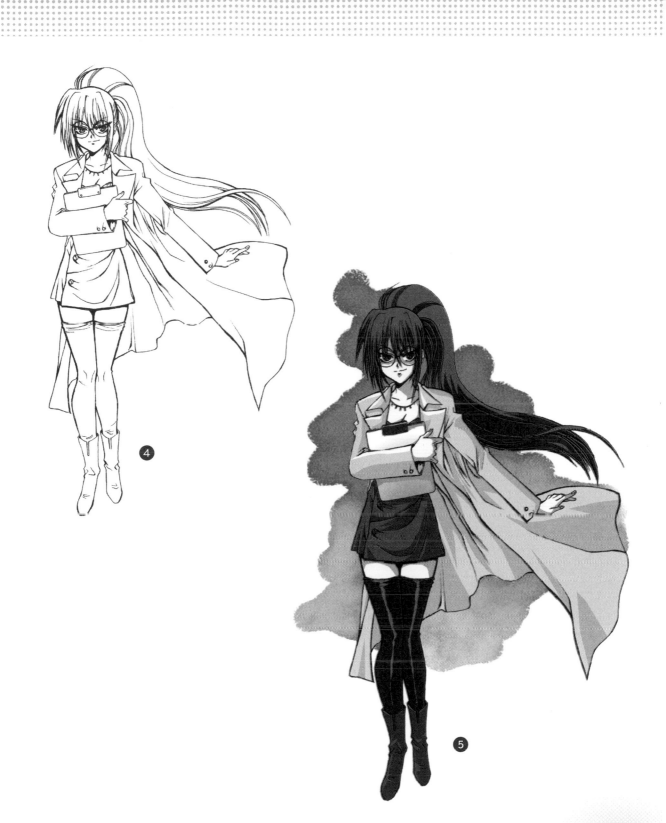

Cat-Girls

Cat-girls are reader favorites. If you want to draw shoujo, these kittenish characters are a really good place to start. Cat-girls are part human and part feline. Although they live among, and interact with, humans, they retain a lot of their cat personality traits, such as curiosity, mischievousness, impulsiveness, and a fondness for milk. They're always attractive, even with their weird cat ears and tails. Some of them have stripes, like tabby cats.

Note the use of wispy colors, rather than a palette of primary colors. Primary colors convey a bold energy. By applying several variations of a single, muted color, like this periwinkle blue, you convey a gentler tone, which makes a shoujo character more sympathetic.

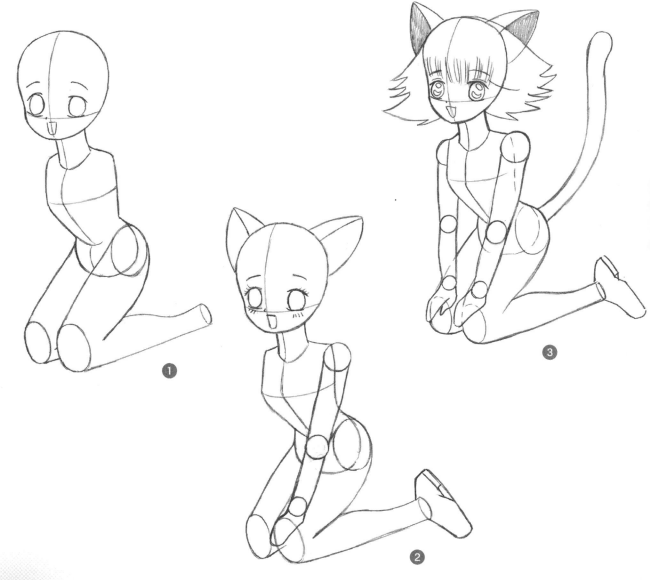

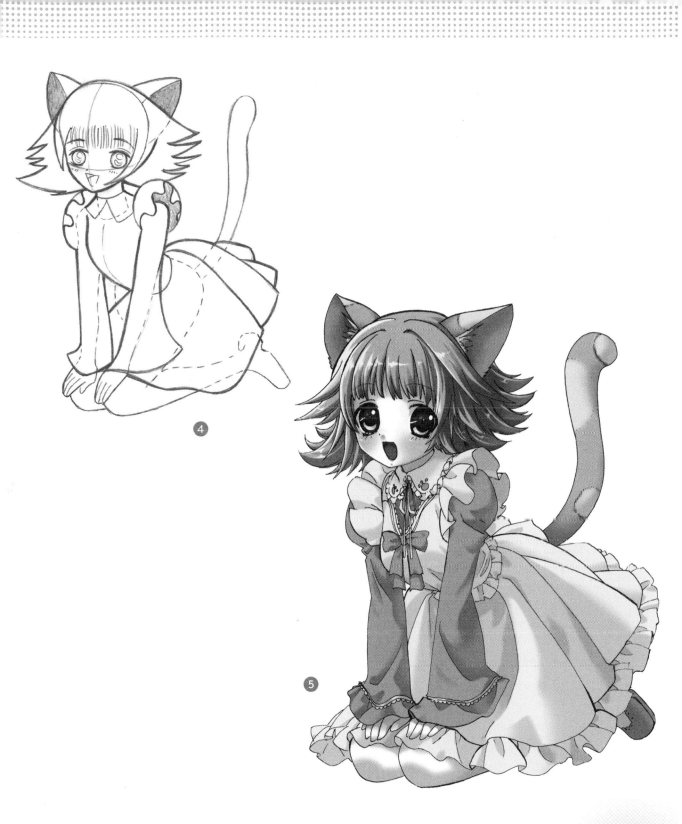

4

5

47

Schoolgirl

A book like this would not be complete without instructions on how to draw schoolgirl characters. Schoolgirls can be sweet or bratty, meek or heroic, ordinary or magical. In other words, they can be anything you want them to be!

In Japan, schoolgirl comics are so popular, they're read by all ages and by both males and females. Remember, even though they're about girls, these stories offer plenty of compelling male costars, which broadens the appeal.

3

1

2

4

Beach Babe

Typical tropical clothes are small tops combined with long skirts. Flowers are popular in Japanese comics, and this character wears a necklace of them (a *lei*) and one in her hair as well. This kind of character should have bare feet and an ankle bracelet, too.

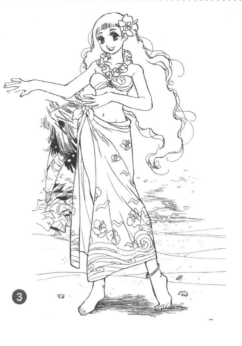

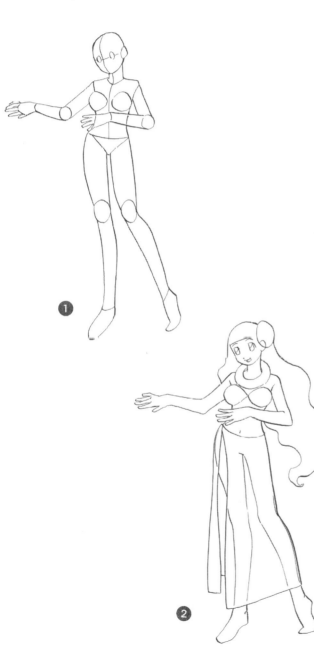

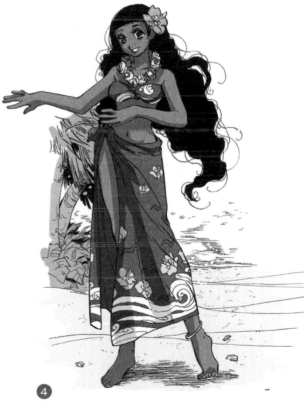

Sunbather

This scene looks like a warm day. How did that happen? Not by chance. It's due to the way the light was portrayed. Show harsh shadows by indicating one light side and one darker side on the body. There is no transition between these tones. It's an abrupt line between light and dark. This girl is wearing a huge hat to protect her from the sun. Note her beach accessories, including a towel, a ball, and a basket.

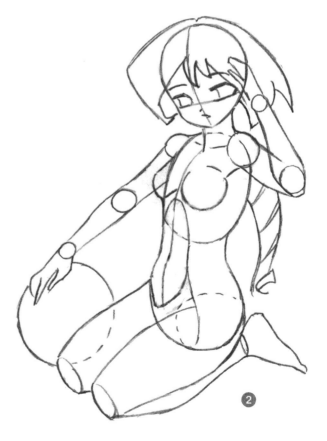

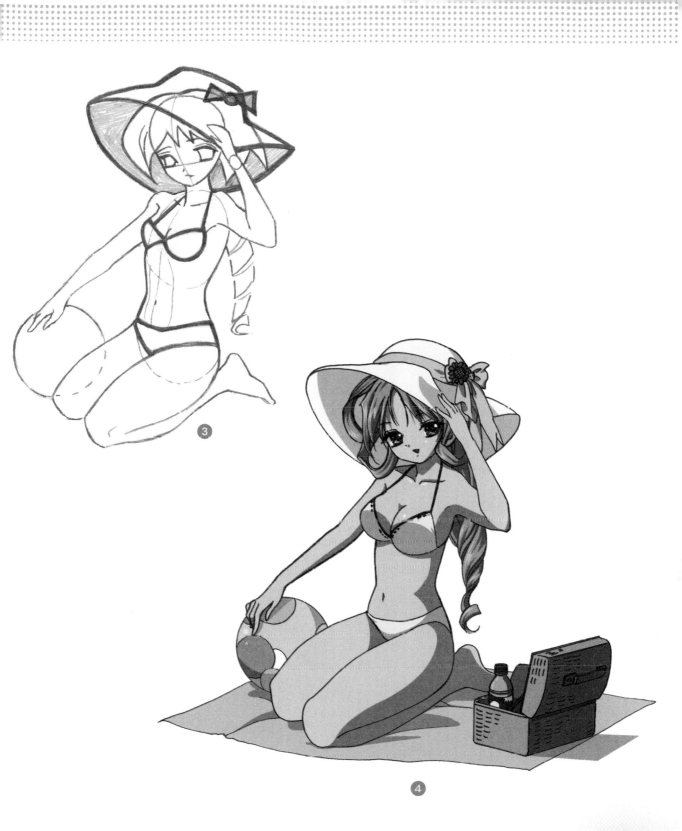

③

④

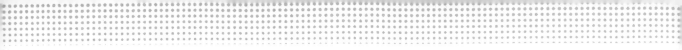

Waitress

Waitresses, and other beautiful, glamorized service workers, are superpopular in manga. These characters can be anything from chefs to stewardesses to hairdressers and hostesses.

Service workers are supposed to be helpful and caring (unless they're providing tech support for my printer!).

The outfit is frilly, pretty, and traditional. So what's with the outrageous hair color? Did she simply not want to hurt the feelings of her color-blind stylist? Or did her younger brother "crayon" it while she was sleeping? No, my suspicious friend, no. Although shoujo characters aren't generally outrageously colored, you can go a bit off the trail by keeping your color selection muted, such as this sea green.

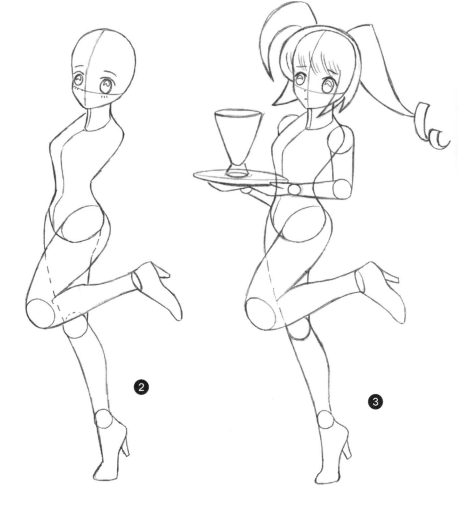

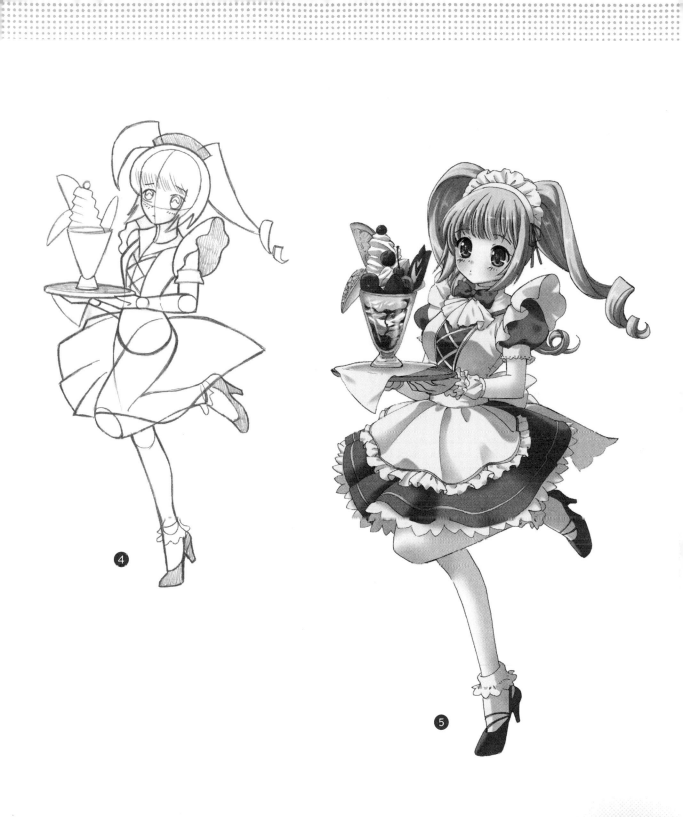

PART THREE
Let's Practice It

Embellish this schoolgirl's outfit with shoujo-style pleats, ruffles, or bows.

Take these plain outfits and add exciting, stylish, shoujo elements to them.

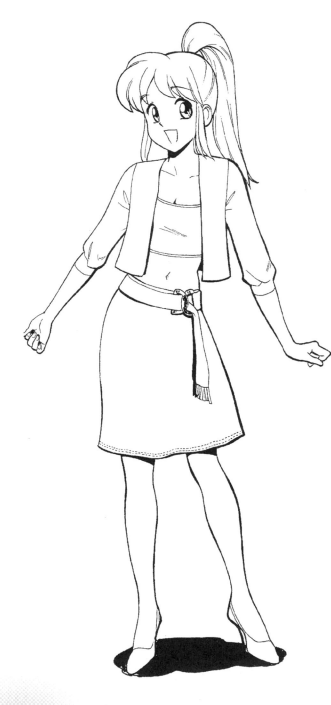

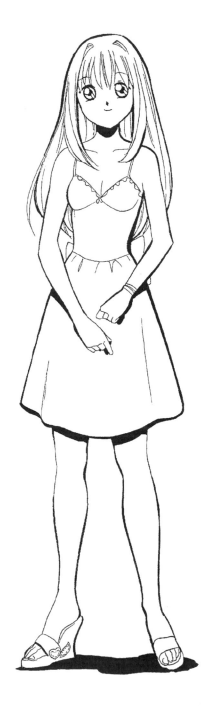

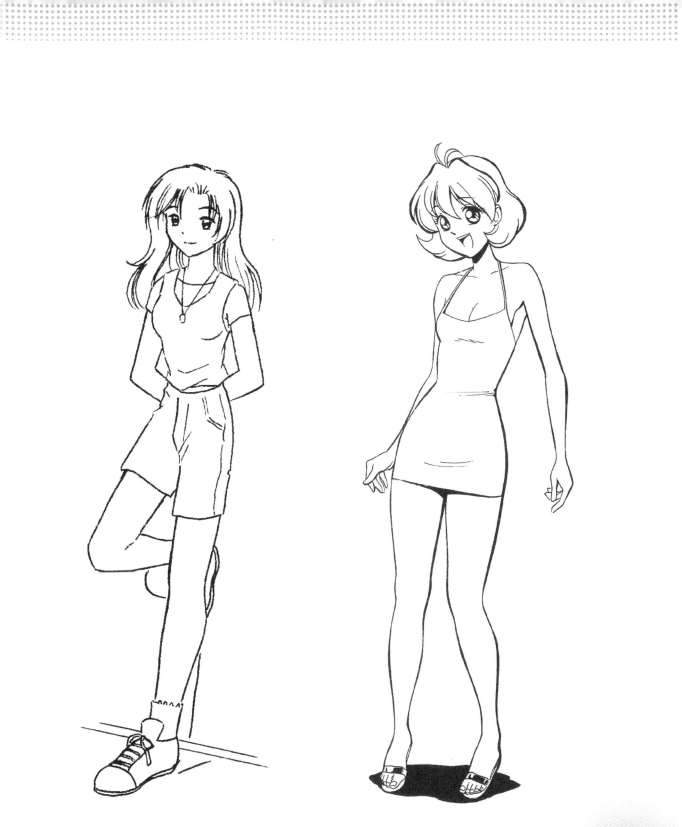

Finish drawing the body of this manga character; what would she wear with these boots?

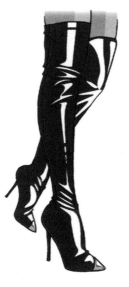

Finish the hairstyle on this character.

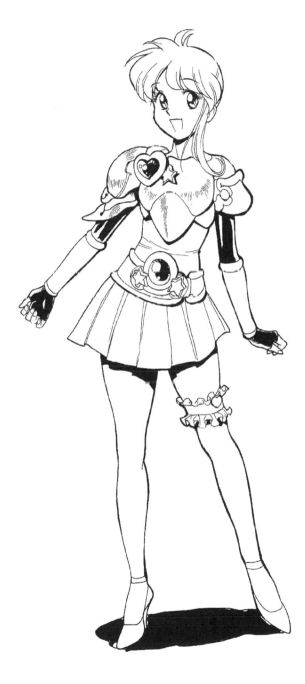

Give these shoujo girls some earrings.

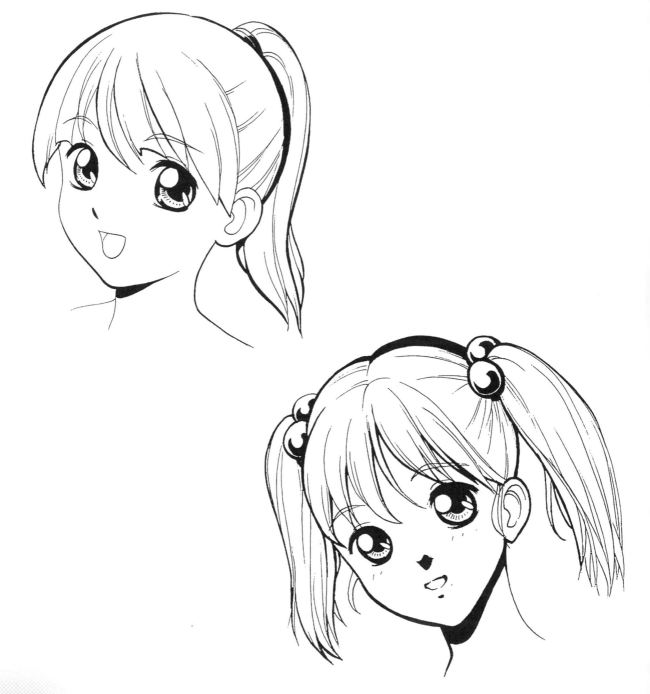

Draw in this runner's sneakers, and give her a cool, sleek running outfit.

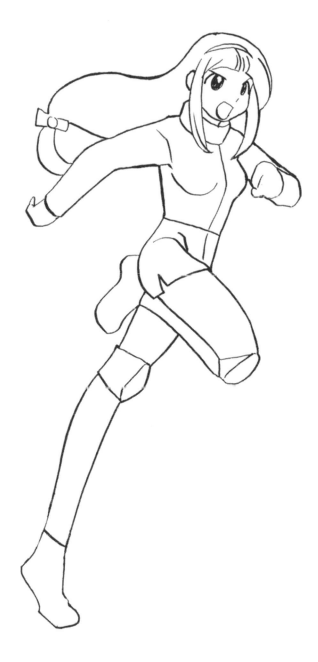

Connect the missing pieces of these shoujo characters, and finish their outfits; they'll need trendy tops and shoes, as well as some accessories.

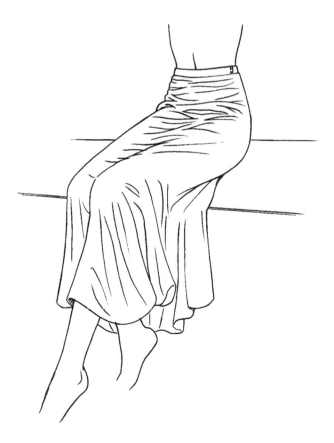

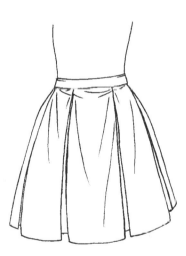

Also available in *Christopher Hart's Draw Manga Now!* series